COOLEST HOMES EVER

ALLI KOCH

T0014891

Paige Tate & Co.

Published by Paige Tate & Co.
Paige Tate & Co. is an imprint of Blue Star Press

PO Box 8835, Bend, OR 97708
contact@paigetate.com
www.paigetate.com

Illustrations by Alli Koch

ISBN: 9781958803592

Printed in China

10 9 8 7 6 5 4 3 2 1

My love for architecture and interior design started at a young age. My dad built a drafting table for me when I was a little girl, and I would spend hours at it imagining all my future dream homes, drawing up different floor plans for each of them. That passion motivated me to study interior design for some time in college, and it also led me to design and build my own dream home—an A-frame cabin in east Texas.

I am endlessly inspired by all the possibilities of combining different materials to create a truly unique home. I created this coloring book to showcase some truly one-of-a-kind homes all over the United States, my A-frame included. The owners of each of these homes turned their own architecture and interior design dreams into realities. They allowed me to draw illustrations of their beloved spaces with the hopes that they will inspire you to do the same.

In the pages that follow, you'll find exterior and interior illustrations of each of these homes, as well as quotes from the homeowners about what makes their spaces so special. You can bring these houses to life in your own unique way by deciding the colors, textures, and materials that you would choose for each setting. There are also two velvet sticker pages featuring fun home decor items that you can use to accentuate the rooms however you'd like.

I hope this book brings you creative comfort and inspiration for your next home project. Enjoy and share your coloring with me on social media by tagging @allikdesign!

Iconic and simplistic, A-frame homes bring you closer to nature. Our vision for our lake-house getaway was to add modern flair to this classic architectural design. It took us over a year to build our A-frame, from finding the perfect land off Richland Chambers Lake in Texas to customizing everything from the ground up. Our hope is that our home provides an escape from modern-day stressors and offers everyone who visits a much-needed reset.

– allie

A-FRAME

——

A-FRAME CHAMBERS

@aframechambers

♀ EAST TEXAS

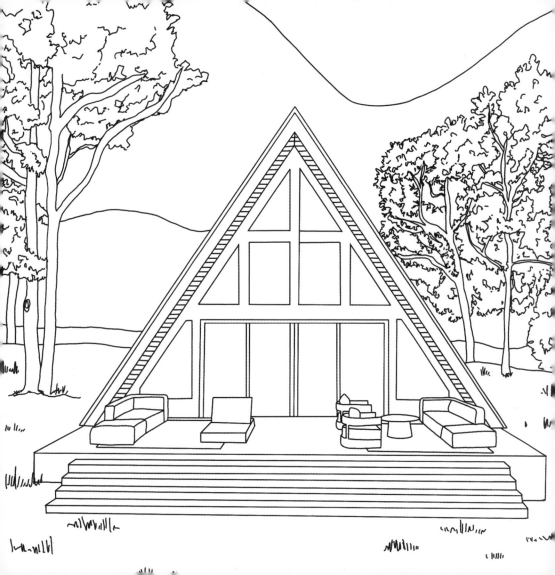

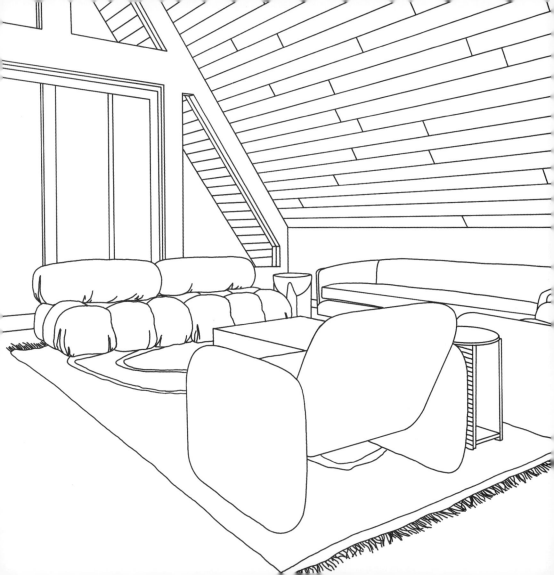

Our home was inspired by our love for modern architecture when paired nicely with warm and inviting interior tones. On a 6-month adventure to New Zealand, we met a fellow named Tom and his fiancée, Sarah, who had built a very similar design. We became friends and ended up working with him to help build our dream home, referencing his design. The name of our house is based on our favorite quote from Ernest Hemingway: "We ate well and cheaply and drank well and cheaply and slept well and warm together and loved each other." We both enjoy the nice things in life in moderation and know how to appreciate what we have without getting caught up in the desire for more.

Anna

MINIMAL MODERN

—

HEMINGWAY HOUSE

@thehemmingwayhouse

📍 **BONITA, CA**

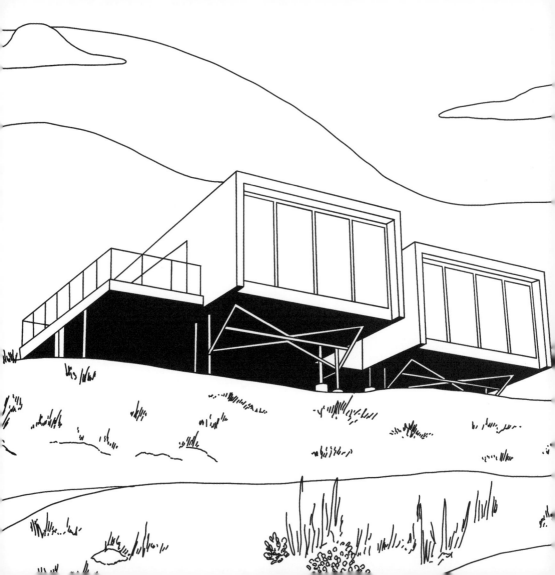

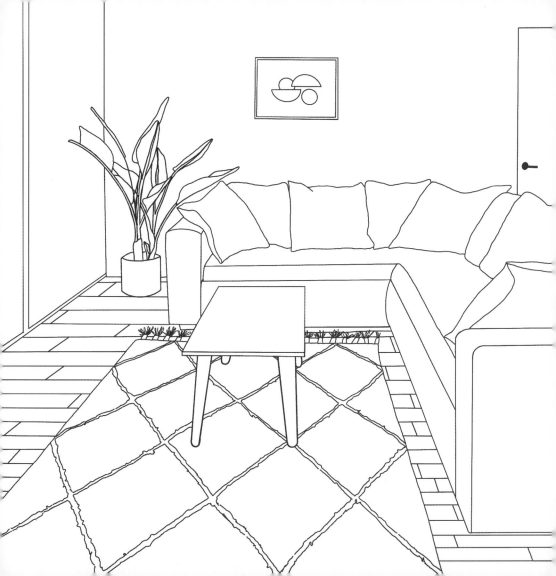

We were inspired to convert a retired school bus into a tiny home after years of traveling without our beloved pup, Cake. We set out to give her the best life, but in return quickly realized this lifestyle was best for all of us. We love that we have our home with us wherever we go, but mostly we love that this decision has reminded us to be more conscious consumers and more intentional about experiencing the magic of our true home, Earth.

SCHOOL BUS

—

ROAMING RIVERS

@roamingrivers

9 ON THE ROAD

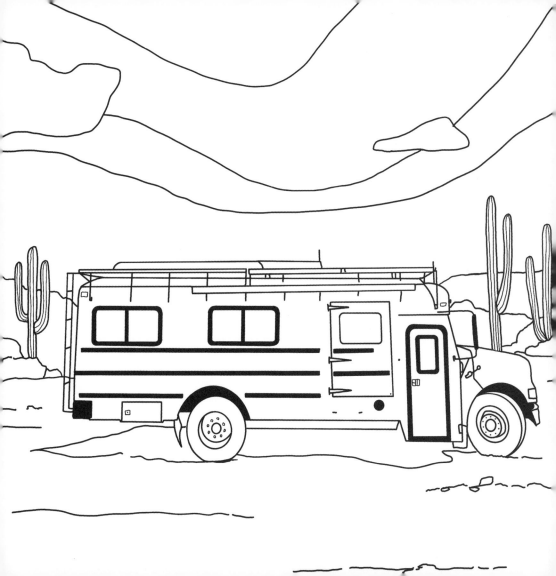

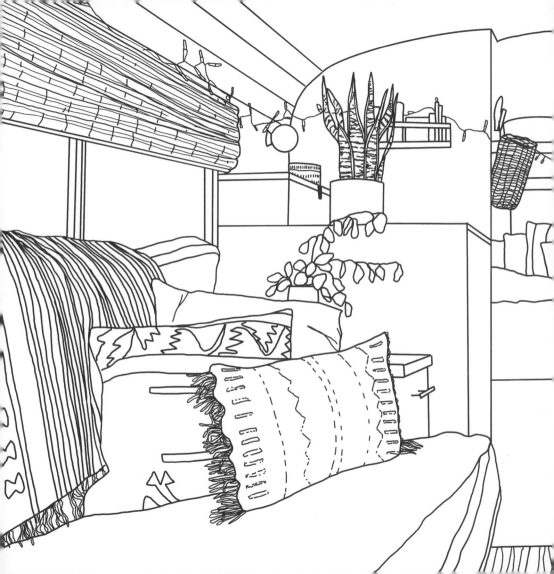

Frequent visitors of far West Texas and passionate natives of the Lone Star State, we found and secured 392 acres of untouched, private high desert land on the Western boundary of Big Bend National Park in 2017 and began work on a private refuge from the demands of city life. The Local Chapter is located in a designated International Dark Sky Area, which provides a distinguished quality of starry nights that can be seen from the comfort of bed through the center dome of each yurt. Visitors can withdraw from obligation and unwind as they explore the last frontier and experience the unique landscape and culture of the Texan West.

YURT

—

THE LOCAL CHAPTER

@thelocalchapter

📍 TERLINGUA, TX

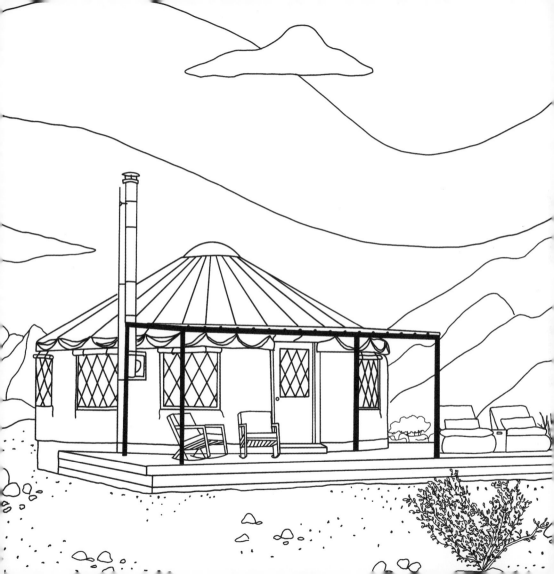

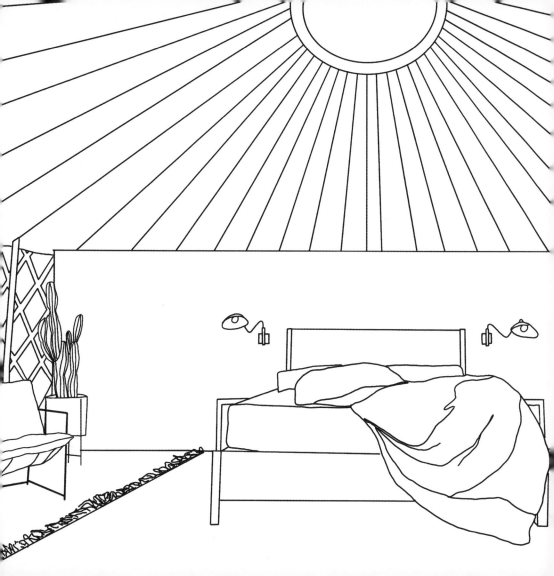

Located in the Shaw neighborhood, one of DC's most hip, slick, and cool areas, "The Firehouse on R" housed the first fully African American fire company in Washington, DC. Built in 1884 and fully renovated in 2017 by a world-famous interior designer and TV celebrity, the firehouse merges exposed architectural beauty with historic photography and modern amenities/design. "Washington, DC, is a city where African Americans fought for and won their civil rights," owner Michael Abbenante said. "This DC Firehouse is not only a historic landmark, but more importantly a sign of African Americans gaining civil rights and breaking the barriers of segregation. You feel PROUD staying here."

FIREHOUSE

—

DC FIREHOUSE

@dcfirehouse

◉ WASHINGTON DC

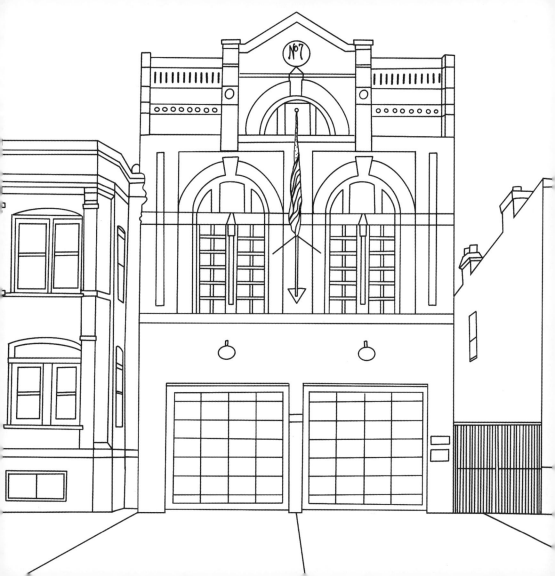

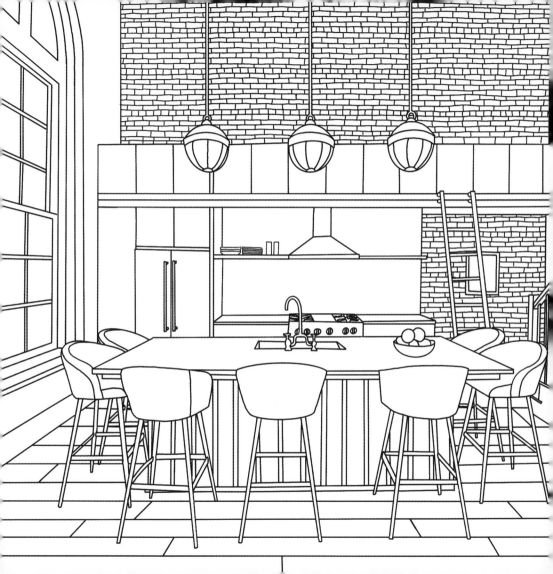

The Peached Casita tiny house was inspired by the Joshua Tree desert and showcases a collection of curated goods from our travels. I designed the architecture for the home, which features two trailers parked in an 'L' shape and large folding doors, to maximize the indoor/ outdoor experience. The colorful appliances, clawfoot tub, and reclaimed wood flooring are our favorite things about the house.

Kim

TINY HOUSE

—

THE PEACHED CASITA

@peachedcasita

📍 **TEXAS HILL COUNTRY**

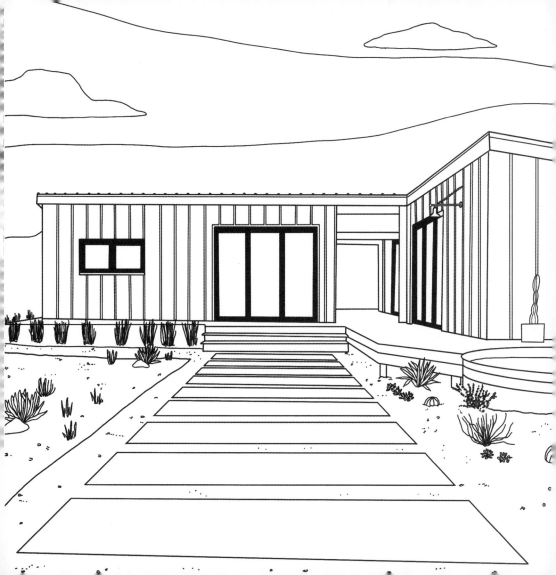

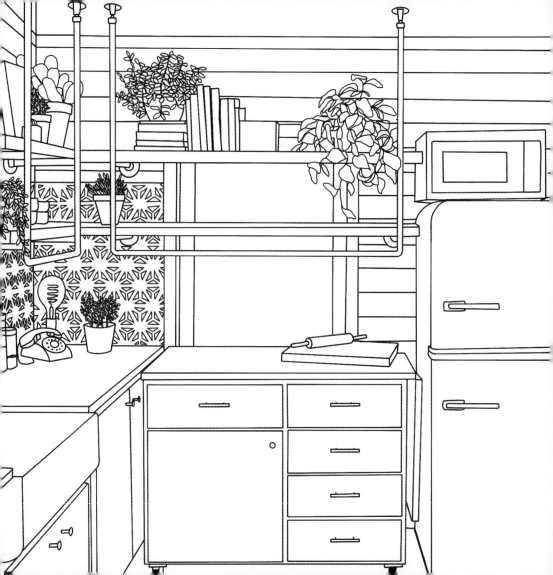

Nestled in the foothills of the Elkhorn Mountains in Clancy, Montana, is the cutest little earth home. It's the perfect little hobbit's retreat with built-in cubby beds, a tree trunk shower, and a hidden room accessed by a secret door. Come stay at Creekside Hideaway and experience this little gem in the woods for yourself!

EARTH HOUSE

—

CREEKSIDE HIDEAWAY

@creeksidehideawaymt

📍 CLANCY, MT

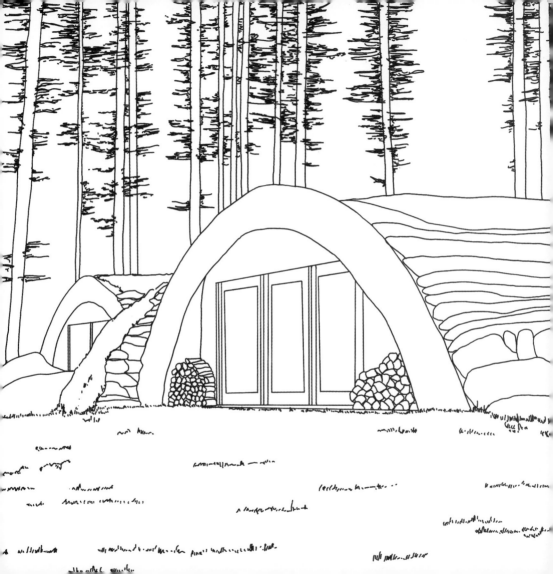

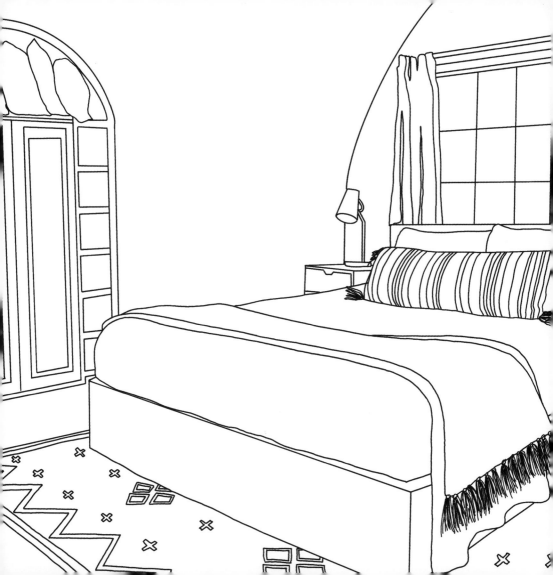

I built Casita Conejo in the heart of Joshua
Tree, California, for $165,000. I've always
had a unique fascination with tiny homes
and mid-century modern architecture. So I
thought, why not combine my favorite things?
I could not love the final product
any more.

Robert

TINY HOUSE

—

CASITA CONEJO

@casitaconejo

📍 **JOSHUA TREE, CA**

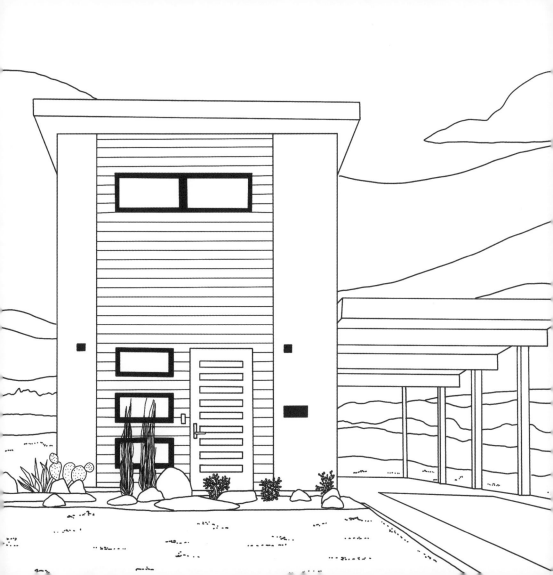

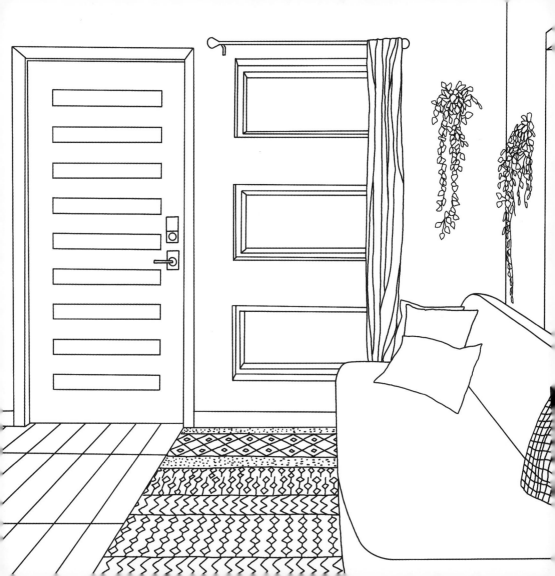

The Texas Geodome was built from a Geodesic Dome Home kit in 1996 and completed in the early 2000s, then fully renovated from top to bottom in 2020 to reflect a mid-century modern design that pays tribute to the original Geodesic dome homes that debuted in the 1960s and '70s. The house is over 3500 square feet with four levels, including an observation tower with 360-degree views of beautiful Lake Travis, and is nestled on .5 acres of land surrounded by trees.

Dan

DOME HOUSE

——

TEXAS GEODOME

@txgeodome

📍 **VOLENTE, TX**

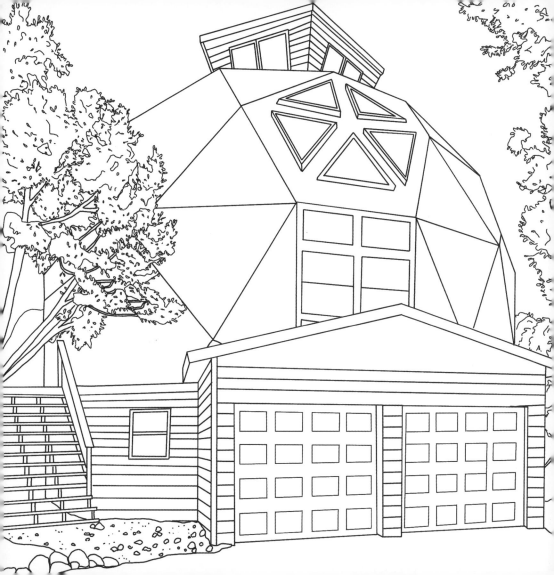

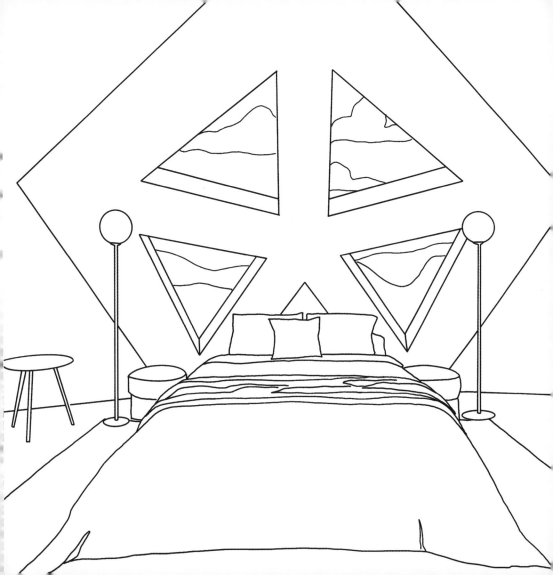

The log cabin that became Little River was once abandoned for almost ten years. It's now a lovingly updated mountain retreat and vacation rental in the Catskills. We spent five years renovating the cabin on our own, making sure the design was grounded in the soul of the cabin's old character for a cozy, contemporary feel.

Lauren

LOG CABIN

—

LITTLE RIVER

@littleriverupstate

📍 **ELDRED, NY**

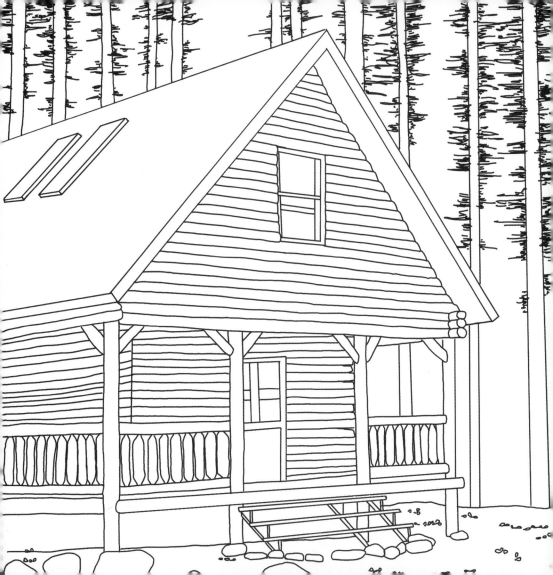

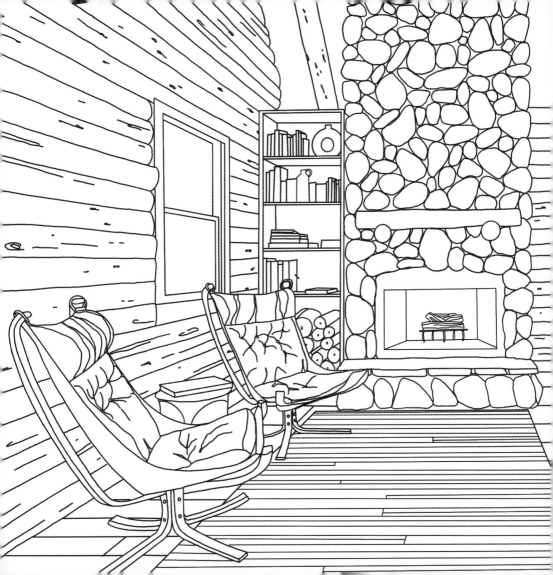

Mavis is a little 1977 Airstream that serves as both a full-time home and office on wheels for Atlanta natives Sheena and Jason and their blind, senior dog. Mavis has traveled all the way from California to Maine and everywhere in between and has redefined what a home is for us. Tired of the views or want warmer weather? With a home on wheels, that's an easy fix!

Sheena & Jason

AIRSTREAM

———

MAVIS

@mavistheairstream

♀ ON THE ROAD

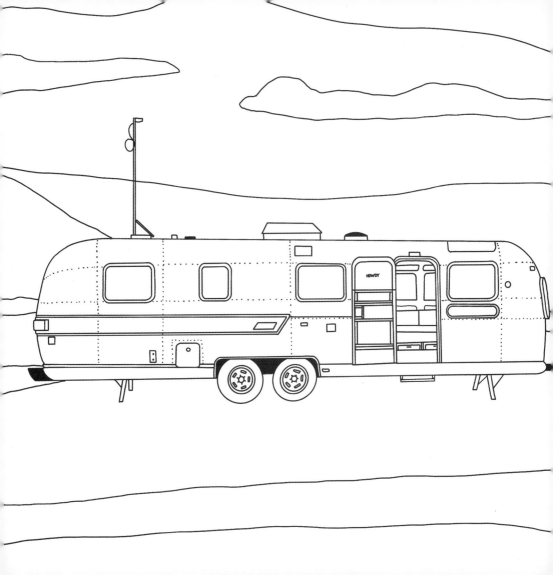

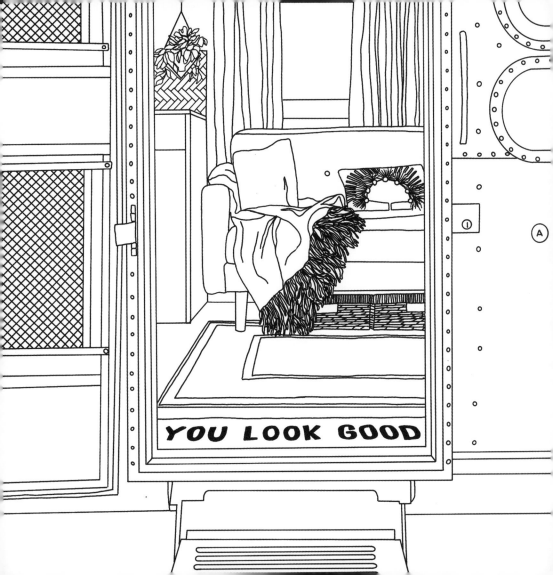

Nestled in the pines of East Texas, just minutes from Canton, our black bohemian brick dream home is a relaxing getaway that's perfect for a mid-week retreat or a full weekend with friends. The home sleeps up to 10 adults and has four queens and two twin XL beds. It has a fully equipped kitchen, screened in porch, outdoor dining table, and handwoven macrame swing patio. Whether you're looking for a cozy getaway with the family, a secluded place to work away from distractions, a creative backdrop for a photo shoot, or a unique venue for an intimate celebration, The Wilde House is perfect for you.

BOHEMIAN FARMHOUSE

—

THE WILDE HOUSE

@thewildehouse

📍 **EAST TEXAS**

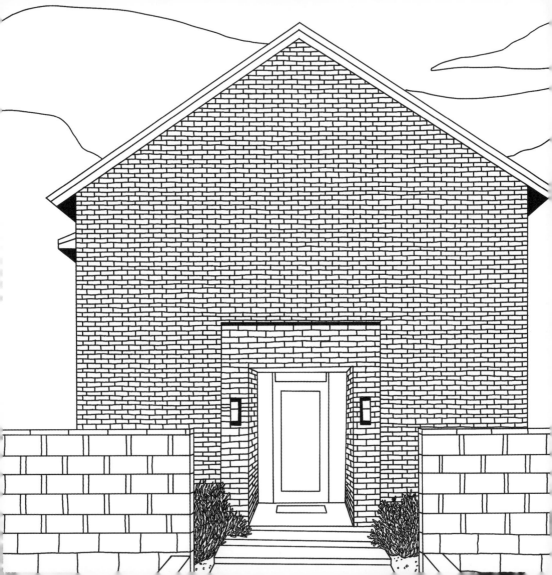

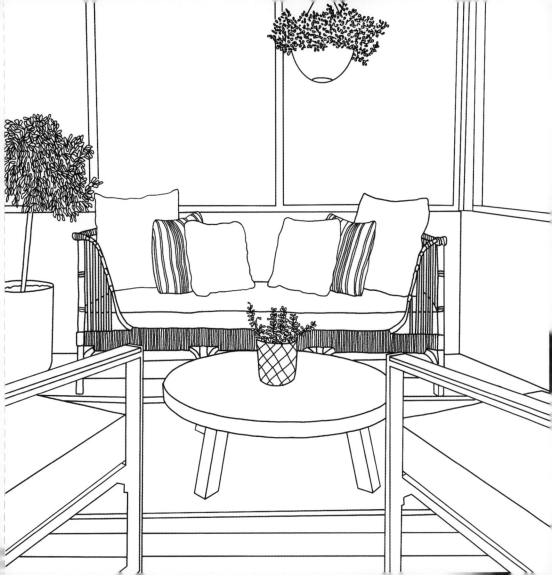

We've worked really hard to bring the authenticity we felt during our travels to Paris and abroad to our spaces. We try to keep as many historical elements as we can, collecting pieces that have a story, using texture and simple furniture to create a space that is both comfortable and special.

Rich & Shannon

VICTORIAN HOME

—

FAHNESTOCK HOUSE

@fahnestockcollective

📍 **LANCASTER, PA**

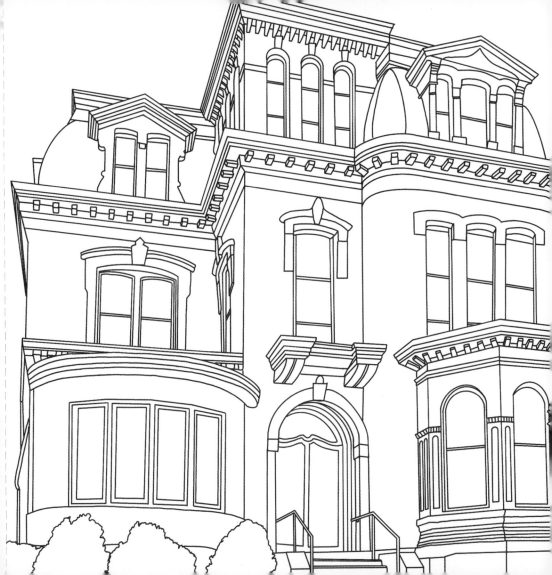

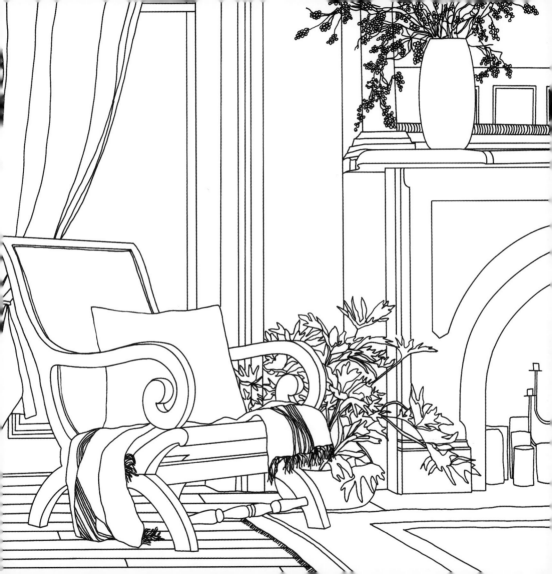

The Live Oak tree house in Fredericksburg, TX, is a stilted luxury cabin built in a cluster of oaks on the Palo Alto creek. Cozy and bright and surrounded by nature, this special home includes a magical book nook with a daybed, sheep skins, and throw pillows under a big round window that looks out into the branches. There is also a large outdoor tub with a tin privacy wall on three sides and an open portion looking out toward the natural scenery of the creek. Described as a "whimsical" and "magical" getaway, the Live Oak tree house is laidback, cozy, and the perfect spot to nestle up with nature!

Katie & Jacob

TREE HOUSE

—

LIVE OAK

@honeytreefbg

📍 **FREDERICKSBURG, TX**

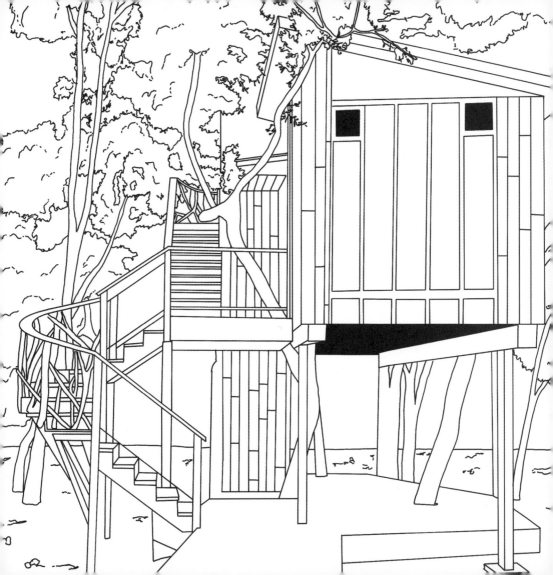

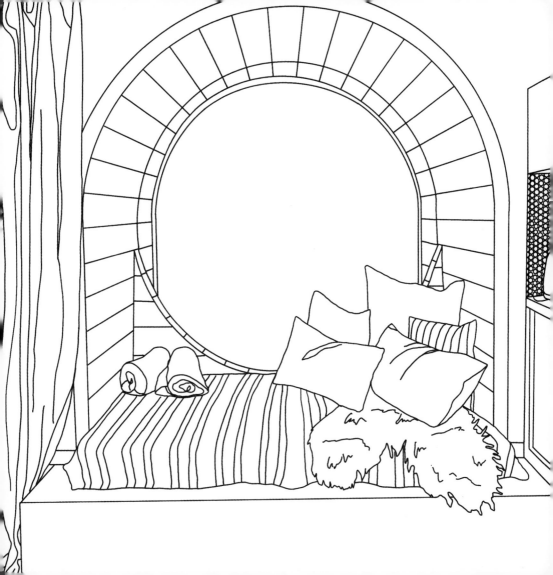

My favorite color has always been black. I've always loved black cars, black clothes, and black nails, so I use the color very obsessively in my home. It's a lifestyle and I'm living for it.

Victoria

ROWHOUSE

—

ALL-BLACK ROWHOUSE

@herblackhome

📍 **BALTIMORE, MD**

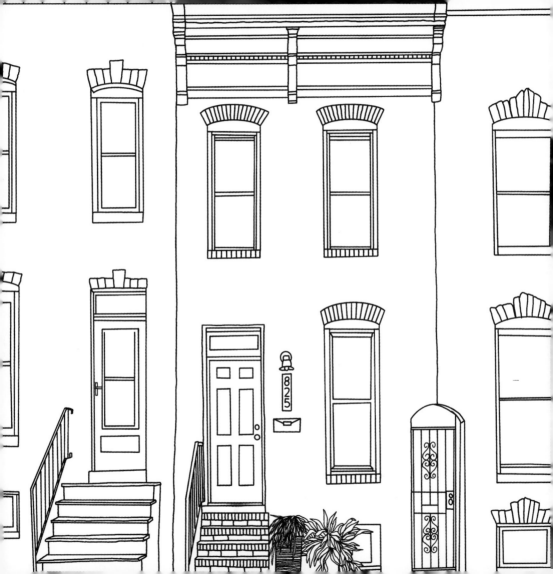

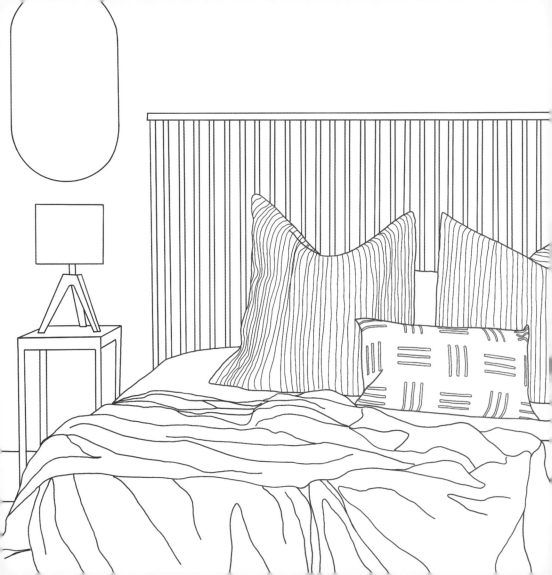

The "Temple of Transformation" is a former church in Dallas that's been transformed to be both a creative business hub and a vital living environment for the owner and CEO of Poo~Pourri, Suzy Batiz. In this space, Suzy hosts women's business retreats, where she teaches other entrepreneurs her feminine approach to business. The feeling, intention, and love invested in the space amplifies and touches everyone who enters. With resonance, energy, creativity and aliveness abounding, it is a sacred gathering space for all who enter—a temple of transformation.

CHURCH

———

THE TEMPLE OF TRANSFORMATION

@suzybatiz

♀ DALLAS, TX

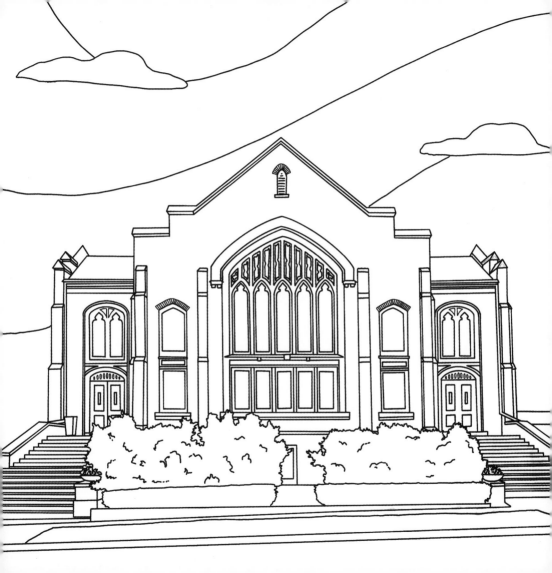

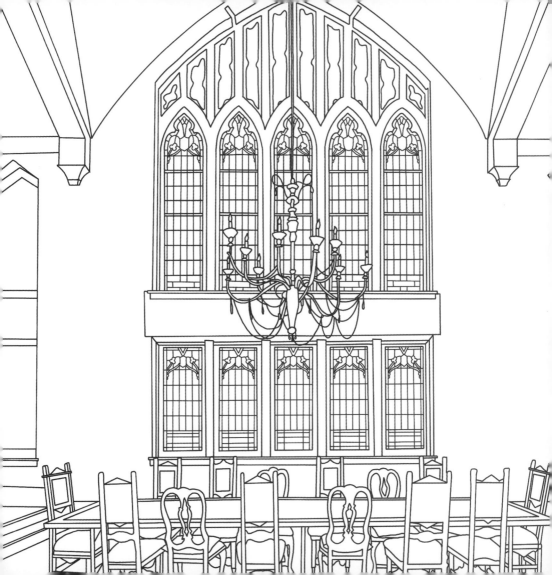

We had rented fire lookouts from the U.S. Forest Service for several years, but as they became more popular with the public, it became harder and harder to get a reservation. So we decided that instead of a ski condo or beach cottage as a second home, we would just build a fire lookout. A few years ago we became disenchanted with our city life and corporate jobs, so we decided we would take a one-year sabbatical and move off-grid and live in our fire lookout full time. Well, it's now been 8 years.

Dabney & Alan

OFF-THE-GRID HOME

—

SUMMIT PRAIRIE LOOKOUT

@summitprairie

📍 TILLER, OR

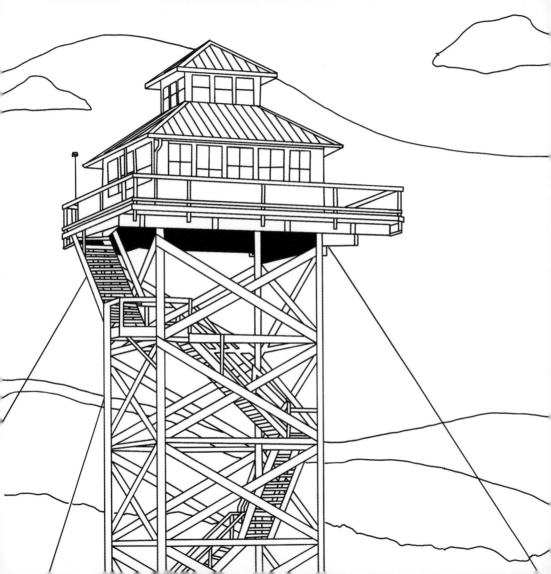

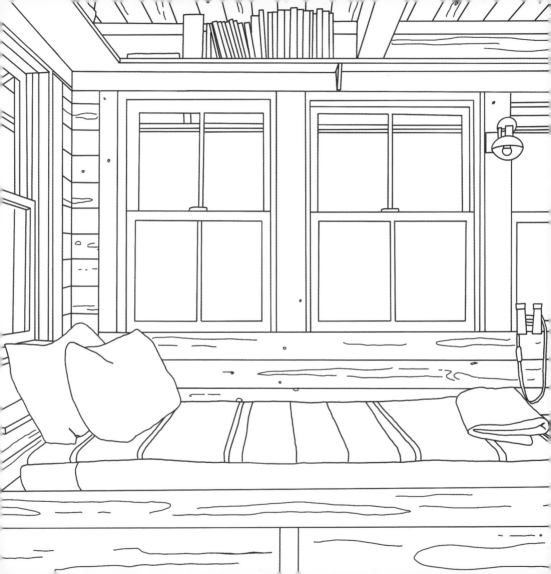

Belding Bliss is Palm Springs meets Palm Beach glamour. An eclectic mix of bold wallpaper and cheerful colors invite guests to relax inside this mid-century home. The home was designed in conjunction with designer Christopher Kennedy and incorporates the owners' love of bold patterns and prints.

Acme House Co.

MID-CENTURY MODERN

——

BELDING BLISS

@acmehouseco

♀ PALM SPRINGS, CA

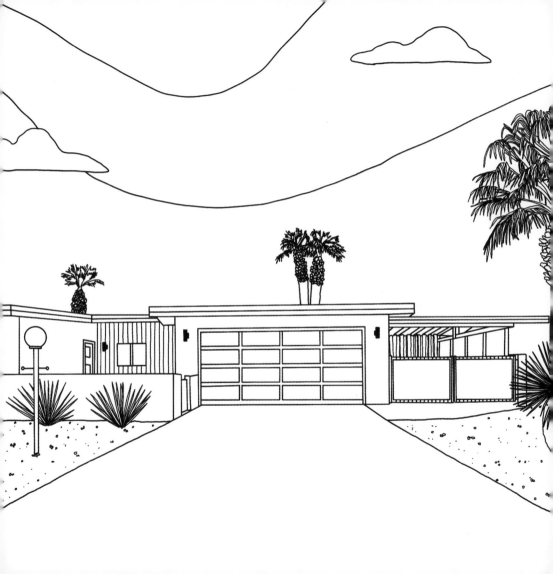

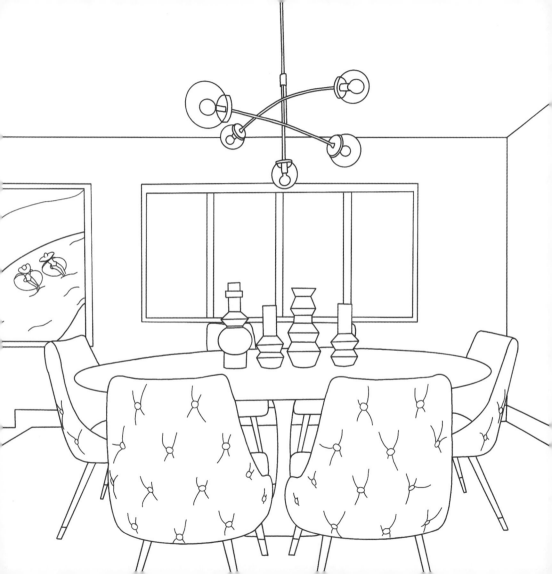

ABOUT ALLI

Alli Koch is the hands and heart behind Alli K Design. She has created a name for herself using her unique drawing style and staple black-and-white color palette. As a visual artist and illustrator, Alli is on a mission to build confidence in others. This has led her to publish multiple books, including *How to Draw Modern Florals, Florals by Hand, Bloom, Heyday,* and her how-to-draw books for kids. She also records a weekly podcast with her dad called "Breakfast with Sis." When she is not out painting murals around her hometown of Dallas, TX, you can find Alli in her studio drinking sweet tea and cuddling with her cats. To find out more about Alli and her work, visit www.AlliKDesign.com.

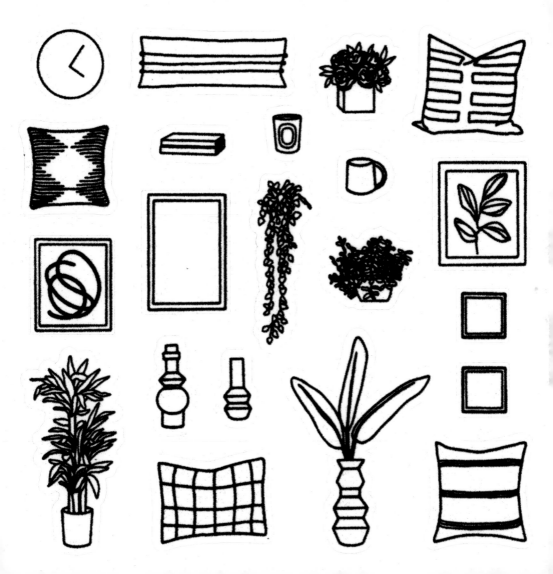

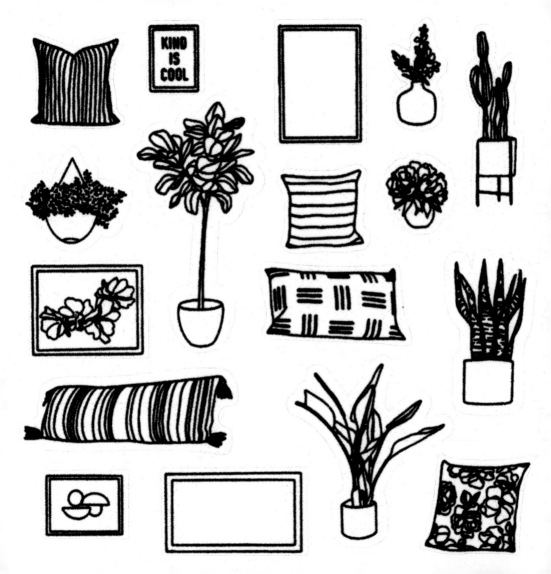